flowers in

art

National

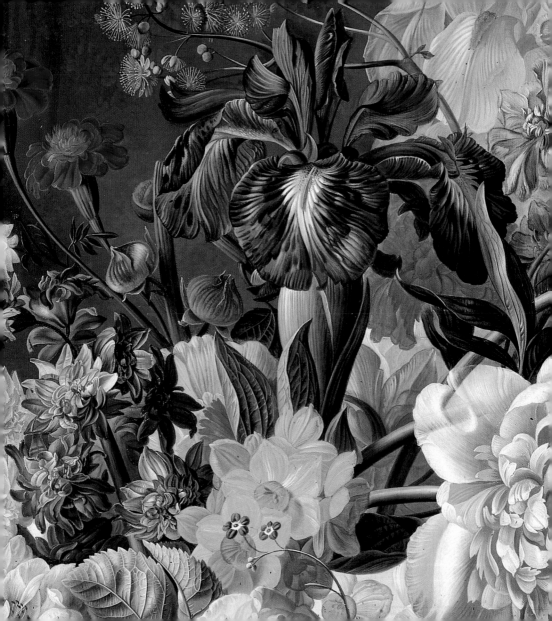

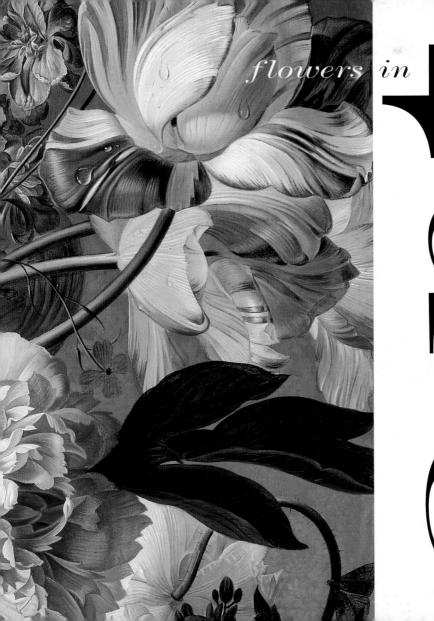

flowers in

National
Gallery

art

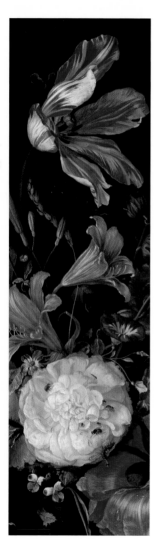

Jacob van Walscappelle, detail of *Flowers in a Glass Vase*

First published in the United States in 2000 by
Watson-Guptill Publications
a division of BPI Communications, Inc.
1515 Broadway
New York, NY 10036

Series editor: Ljiljana Ortolja-Baird
Designer: Philippa Jarvis
Design concept: Bet Ayer

Library of Congress Card Number: 99–68598

ISBN: 0–8230–0340–X

First published in the United Kingdom in 2000 by
MQ Publications Ltd., 254–258 Goswell Road,
London EC1V 7RL in association with the
National Gallery Company Ltd., London

Printed and bound in Italy

1 2 3 4 5 6 7 8 / 07 06 05 04 03 02 01 00

Title page: Paulus Theodorus van Brussel,
detail of *Flowers in a Vase*

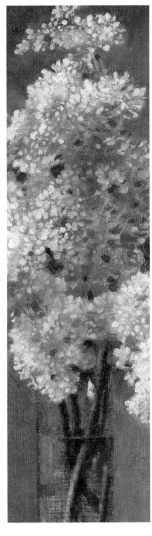

title Franz Schüöaefer, detail of Lilac

INTRODUCTION

"As painting, so poetry." Like all siblings, the Sister Arts are rivals and allies. In the mirrors they hold up to nature we see the beauty of the world around us reflected from varying angles and by different lights.

The National Gallery in London houses many of the world's most famous paintings, many of which incorporate flowers. In whatever context—whether appearing in a portrait as subtle symbols for aspects of the subject's personality, in delicately styled still lives or as masses of riotous color filling the frame of the painting—the beauty and glory of flowers have inspired artists throughout history.

By presenting the paintings in detail, *Flowers in Art* helps us discover aspects of these images we never "knew" were there, and by pairing text and picture, it enhances the descriptive powers of both painting and literature, encouraging us to hone our responses to each.

Erika Langmuir
Head of Education, National Gallery, 1988–1995

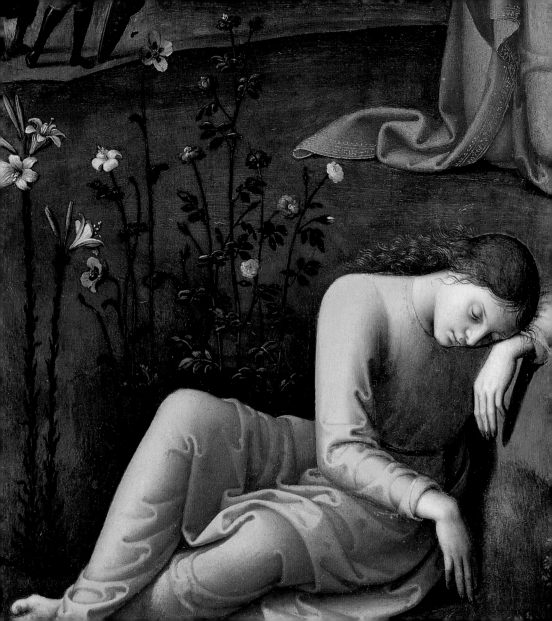

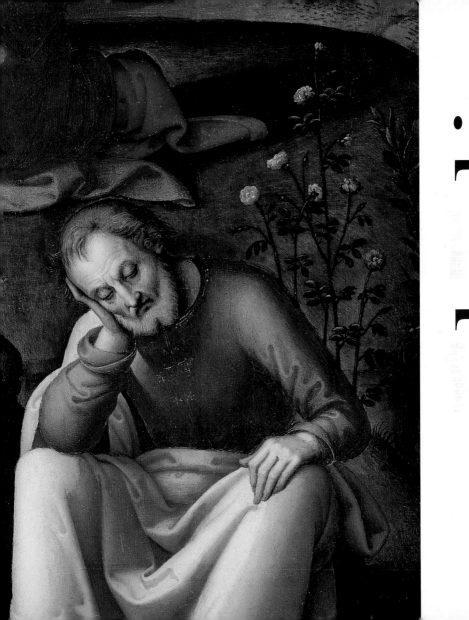

symbolic

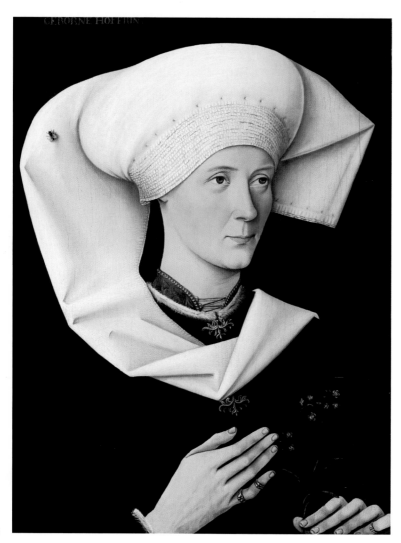

SWABIAN

Portrait of a Woman of the Hofer Family
about 1470

Forget me not when daybreak, shy and pale,
Opens her magic palace to the sun;
Forget me not when pensive night floats on,
Absorbed in dream beneath her silvery veil;
When in thy trembling bosom pleasure calls,
In evening reveries as darkness falls,
Then from the woodland depths hear rise
The murmurs of a voice that sighs
Forget me not.

Forget me not when fate decrees we part
And we for ever take our leave with tears,
When grief and bitter exile and the years
Have rendered sere this blighted, desperate heart;
Remember then my love and last farewell!
Nor time nor absence counts when one loves well.
So long as my poor heart will beat,
For full so long will it entreat:
Forget me not.

Forget me not when in the earth's cold bosom
My broken heart will sleep in endless gloom;
Forget me not when on my lonely tomb
There will unfold the solitary blossom.
No more thou'lt see me; yet my deathless spirit
Will hover round thee faithfully. O hear it
When underneath the stars there rise
The choirs of a voice that sighs
Forget me not.

Forget Me Not,
ALFRED DE MUSSET, 19th century

FRA FILIPPO LIPPI
(*c.*1406–1469) Italian
The Annunciation
late 1450s?

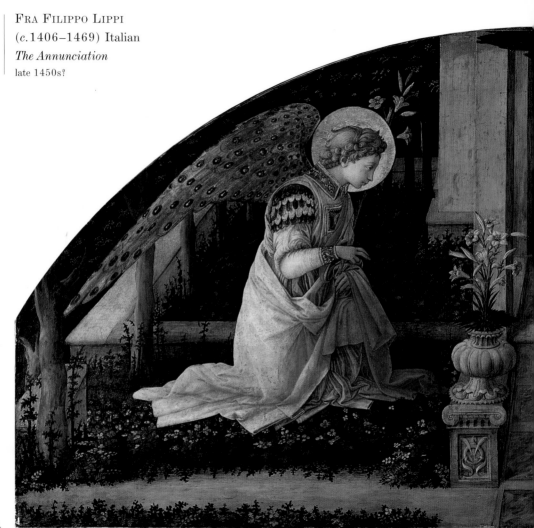

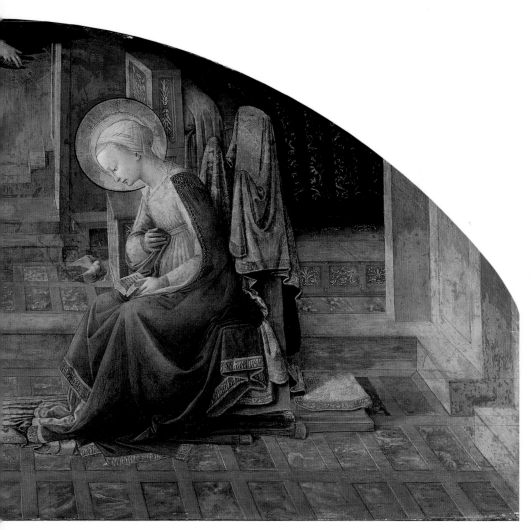

'Blessed art thou of women!' Half she heard,
Hands folded and face bowed, half long had known,
The message of that clear and holy tone,
That fluttered hot sweet sobs about her heart;
Such serene tidings moved such human smart.
Her breath came quick as little flakes of snow.
Her hands crept up her breast. She did but know
It was not hers. She felt a trembling stir
Within her body, a will too strong for her
That held and filled and mastered all. With eyes
Closed, and a thousand soft short broken sighs,
She gave submission; fearful, meek, and glad…

She wished to speak. Under her breasts she had
Such multitudinous burnings, to and fro,
And throbs not understood; she did not know
If they were hurt or joy for her; but only
That she was grown strange to herself, half lonely,

All wonderful, filled full of pains to come
And thoughts she dare not think, swift thoughts and dumb,
Human, and quaint, her own, yet very far,
Divine, dear, terrible, familiar ...
Her heart was faint for telling; to relate
Her limbs' sweet treachery, her strange high estate,
Over and over, whispering, half revealing,
Weeping; and so find kindness to her healing.
'Twixt tears and laughter, panic hurrying her,
She raised her eyes to that fair messenger.
He knelt unmoved, immortal; with his eyes
Gazing beyond her, calm to the calm skies;
Radiant, untroubled in his wisdom, kind.
His sheaf of lilies stirred not in the wind.

from *Mary and Gabriel,*
RUPERT BROOKE, 1912

17

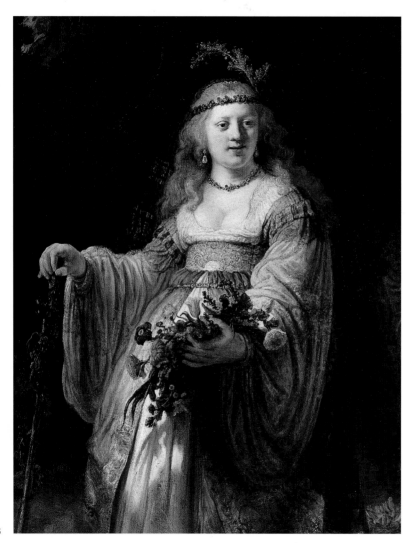

REMBRANDT (1606–1689) Dutch
Saskia van Uylenburgh in Arcadian Costume
1635

I.

Sweet serene skye-like flower,
Haste to adorn her bower;
From thy long clowdy bed
Shoot forth thy damaske head.

II.

New-startled blush of FLORA!
The griefe of pale AURORA,
Who will contest no more,
Haste, haste, to strowe her floore.

III.

Vermilion ball, that's given
From lip to lip in Heaven;
Loves couches cover-led,
Haste, haste, to make her bed.

IV.

Dear offspring of pleas'd VENUS,
And jollie plumpe SILENUS;
Haste, haste, to decke the haire,
Of th' only sweetly faire.

V.

See! rosie is her bower,
Her floore is all this flower;
Her bed a rosie nest
By a bed of roses prest.

VI.

But early as she dresses,
Why fly you her bright tresses?
Ah! I have found, I feare;
Because her cheekes are neere.

To Lucasta: The Rose,
RICHARD LOVELACE, 17th century

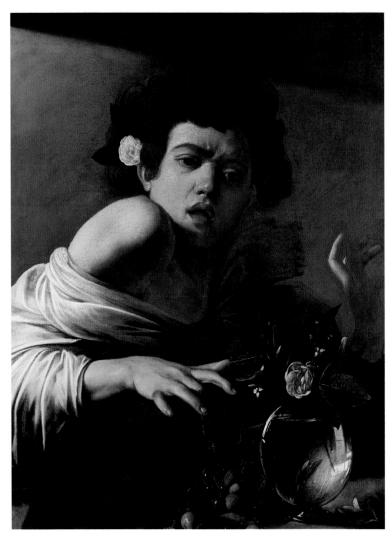

MICHELANGELO MERISI DA CARAVAGGIO
(1571–1610) Italian
Boy bitten by a Lizard
1595–1600

If spicy-fringed pinks that blush and pale
With passions of perfume,—if violets blue
That hint of heaven with odor more than hue,—
If perfect roses, each a holy Grail
Wherefrom the blood of beauty doth exhale
Grave raptures round,—if leaves of green as new
As those fresh chaplets wove in dawn and dew
By Emily when down the Athenian vale
She paced, to do observance to the May,
Nor dreamed of Arcite nor of Palamon,—
If fruits that riped in some more riotous play
Of wind and beam that stirs our temperate sun,—
If these the products be of love and pain,
Oft may I suffer, and you love, again.

To My Class: On Certain Fruits and Flowers Sent Me in Sickness,
SIDNEY LANIER, 1884

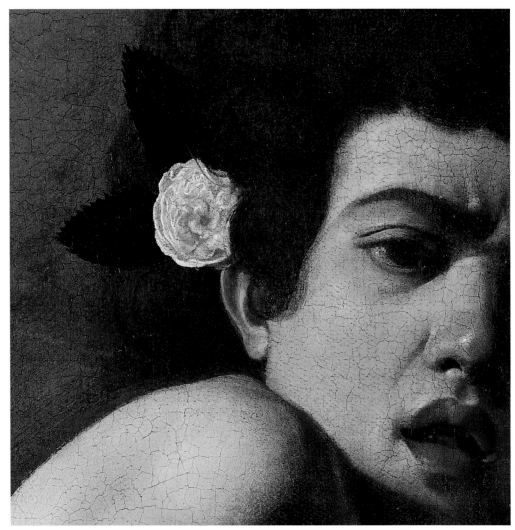

24

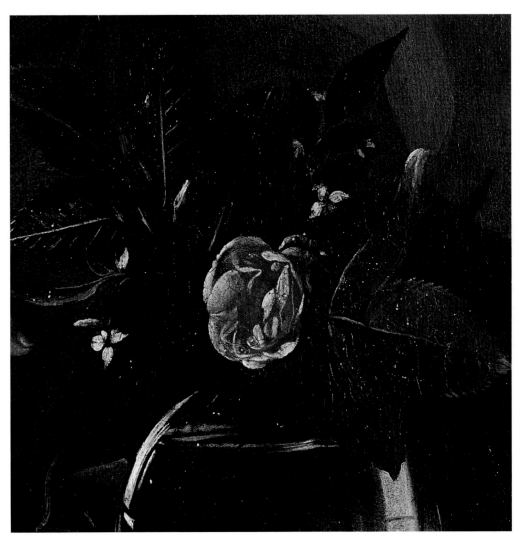

Workshop of GIOVANNI BELLINI
(Bellini, active about 1459; died 1516,
Italian)
Saint Dominic
about 1515

The white and gold flowers and the wine,
Symbols of all that is not mine,
Stand sacramental, and so bless
The wounded mind with loveliness
That it leaps blindly to evade
The world's anguish there portrayed.
What of the water and the green?
I know what leaves and water mean—
The bright blade and the limpid flow,
I knew and loved them long ago;
But now the white, the gold, the blood
Dawn doomlike, not to be withstood.

At the white, gold and crimson gate
I and my heart stand still and wait.

Lilies and Wine,
RUTH PITTER, 1945

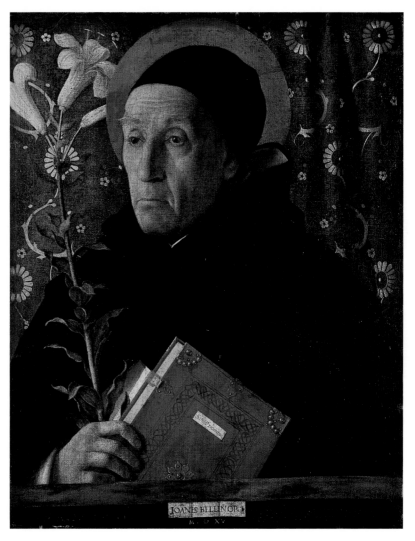

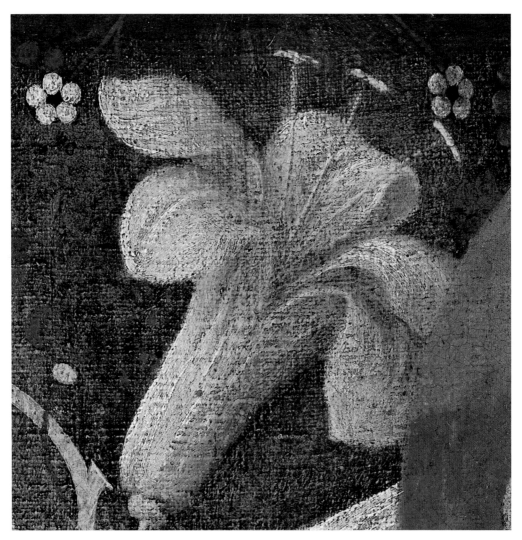

28

German, South
Portrait of a Man
about 1530–40

O that I once past changing were,
Fast in thy Paradise, where no flower can wither!
Many a spring I shoot up fair,
Offring at heav'n, growing and groaning thither:
Nor doth my flower
Want a spring-shower,
My sinnes and I joining together.

But while I grow in a straight line,
Still upwards bent, as if heav'n were mine own,
Thy anger comes, and I decline:
What frost to that? what pole is not the zone,
Where all things burn,
When thou dost turn,
And the least frown of thine is shown?

And now in age I bud again,
After so many deaths I live and write;
I once more smell the dew and rain,
And relish versing: O my onely light,
It cannot be
That I am he
On whom thy tempests fell all night.

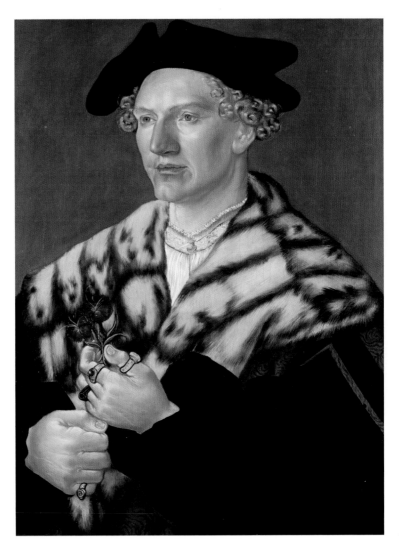

These are thy wonders, Lord of love,
To make us see we are but flowers that glide:
Which when we once can find and prove,
Thou hast a garden for us, where to bide.
Who would be more,
Swelling through store,
Forfeit their Paradise by their pride.

from *The Flower,*
GEORGE HERBERT, 1633

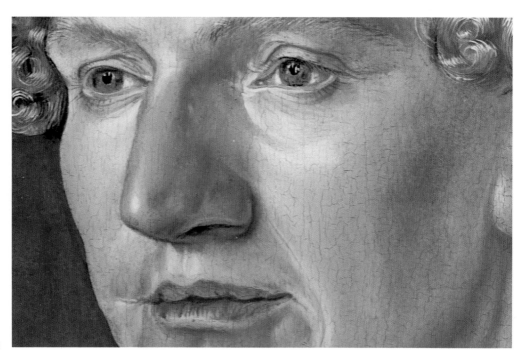

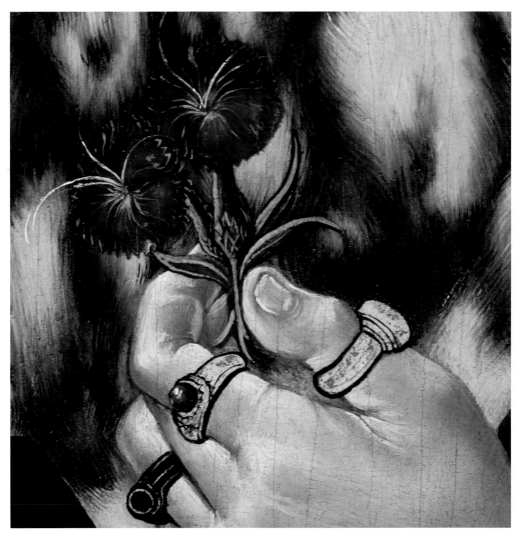

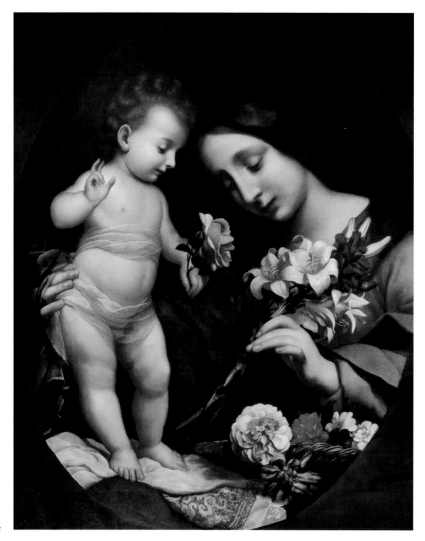

CARLO DOLCI (1616–1686) Italian
The Virgin and Child with Flowers
1650–86

At morn I plucked a rose and gave it Thee,
A rose of joy and happy love and peace,
A rose with scarce a thorn:
But in the chillness of a second morn
My rose bush drooped, and all its gay increase
Was but one thorn that wounded me.

I plucked the thorn and offered it to Thee;
And for my thorn Thou gavest love and peace,
Not joy this mortal morn:
If Thou hast given much treasure for a thorn,
Wilt Thou not give me for my rose increase
Of gladness, and all sweets to me?

My thorny rose, my love and pain, to Thee
I offer; and I set my heart in peace,
And rest upon my thorn:
For verily I think tomorrow morn
Shall bring me Paradise, my gift's increase,
Yea, give Thy very Self to me.

A Rose Plant in Jericho,
Christina Rossetti, *c.*1873

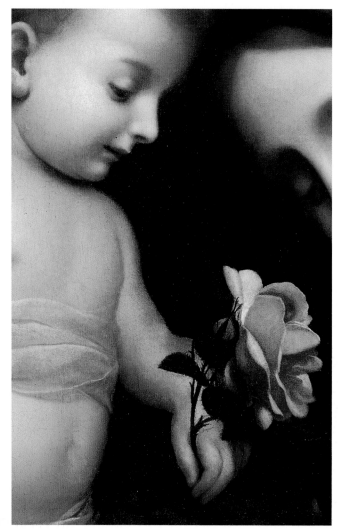

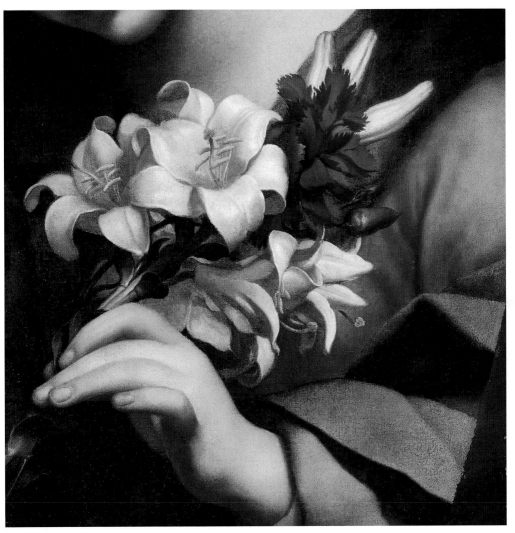

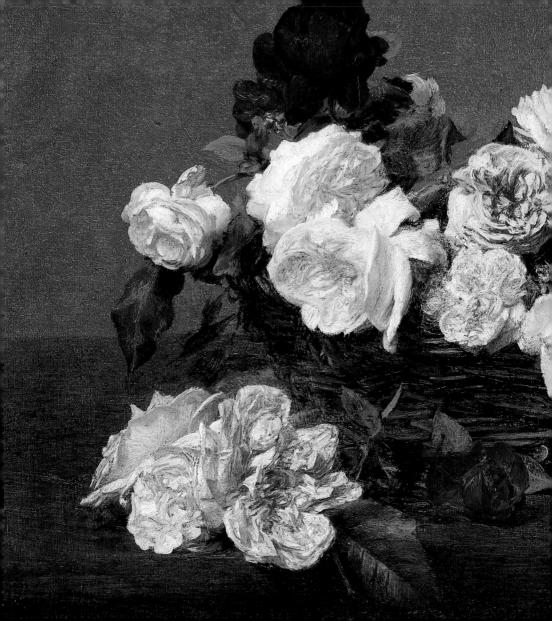

romantic

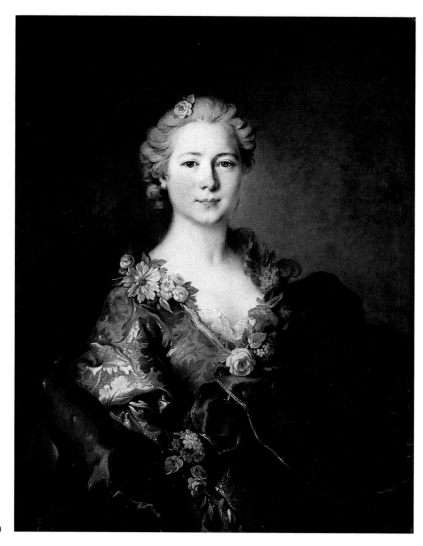

LOUIS TOCQUE (1696–1772) French
Portrait of Mademoiselle de Coislin (?)
probably 1750–9

There is a garden in her face
Where roses and white lilies grow;
A heav'nly paradise is that place
Wherein all pleasant fruits do flow.
There cherries grow which none may buy,
Till 'Cherry ripe' themselves do cry.

Those cherries fairly do enclose
Of orient pearl a double row,
Which when her lovely laughter shows,
They look like rose-buds fill'd with snow;
Yet them nor peer nor prince can buy,
Till 'Cherry ripe' themselves do cry.

Her eyes like angels watch them still,
Her brows like bended bows do stand,
Threat'ning with piercing frowns to kill
All that attempt with eye or hand
Those sacred cherries to come nigh,
Till 'Cherry ripe' themselves do cry.

There Is a Garden in her Face,
THOMAS CAMPION, 1617

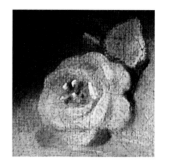

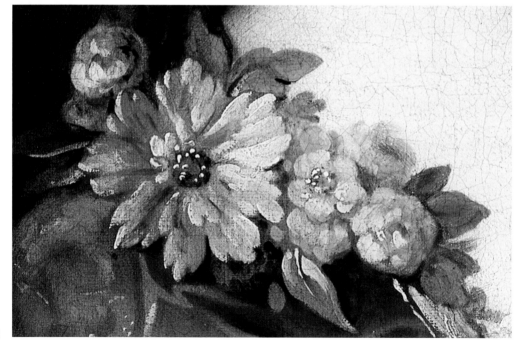

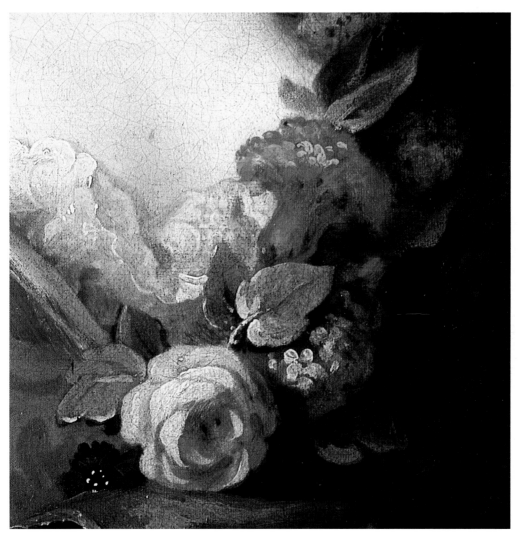

ODILON REDON (1840–1916) French
Ophelia among the Flowers
about 1905–8

So many roses in the garden
Of last night's dream, and all were golden—
Ophelia's flowers of love forsaken,
Yellow rose of luckless loving
Or the golden flower of wisdom?

There, in a night of late November
Fantasy had grown so many
In a garden I had planted
(So the dream told me) long before.
Yet I searched among the gold
For even one of true rose colour,
And found none; dream cannot lie,
None I found of love's true flower.

A Dream of Roses,
KATHLEEN RAINE, 1971

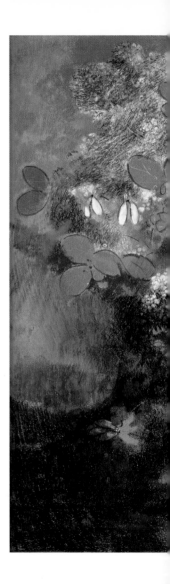

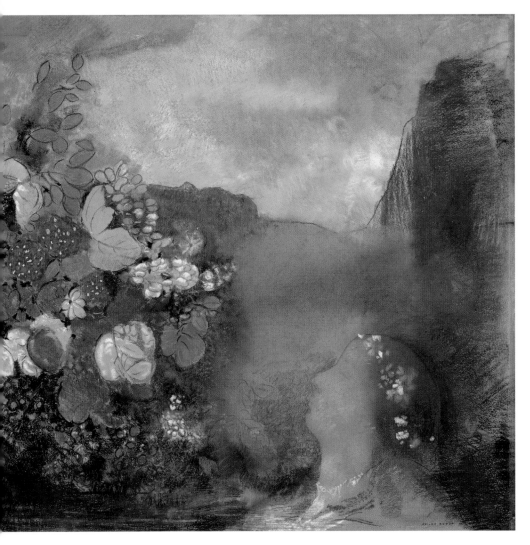

46

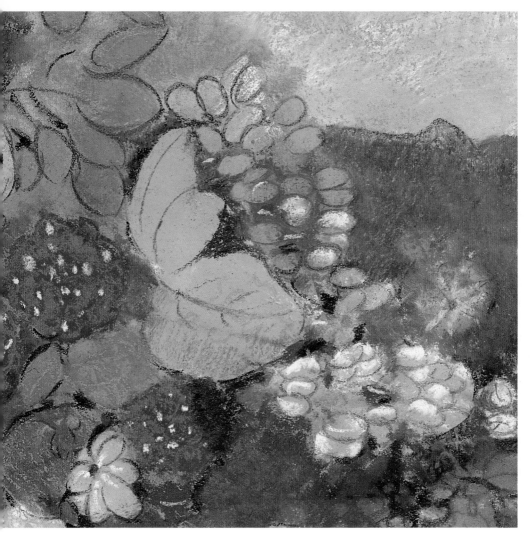

47

Studio of BOUCHER (François Boucher,
1703–1770, French)
The Billet-Doux
1754

The red rose whispers of passion,
And the white rose breathes of love;
O, the red rose is a falcon,
And the white rose is a dove.

But I send you a cream-white rosebud
With a flush on its petal tips;
For the love that is purest and sweetest
Has a kiss of desire on the lips.

A White Rose,
JOHN BOYLE O'REILLY, 19th century

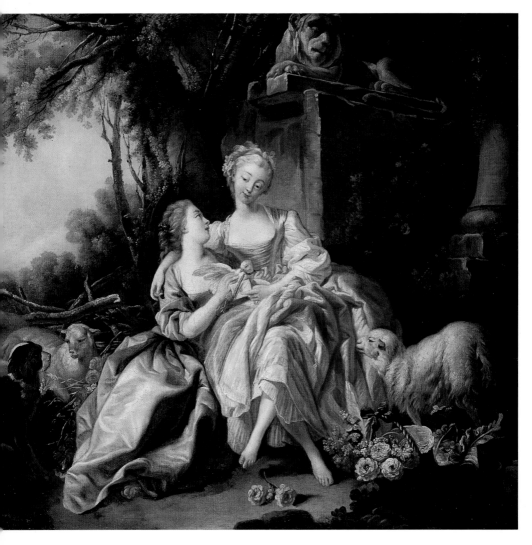

JEAN-MARC NATTIER
(1685–1766) French
Manon Balletti
1757

My love is like a red, red rose
Her beauty makes you stare,
She stands alone near garden lawns
While bees hum in her hair.

My love is like a red, red rose
Her body's green and thin,
And when I try to squeeze her waist
She sticks her prickles in.

My love is like a red, red rose
She's wilting by the hour,
It makes no sense to fall in love
With someone like a flower.

My Love is like a Red, Red Rose,
STEVE TURNER, 1996

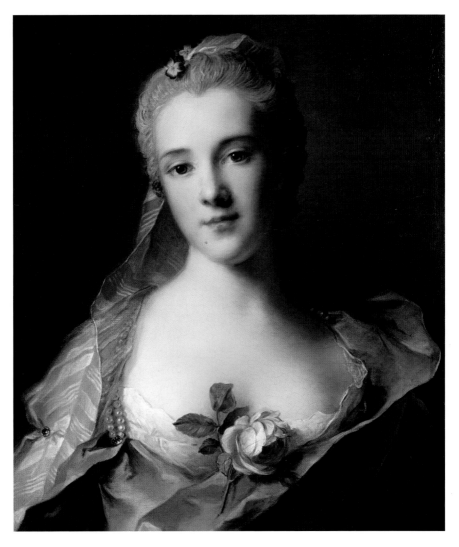

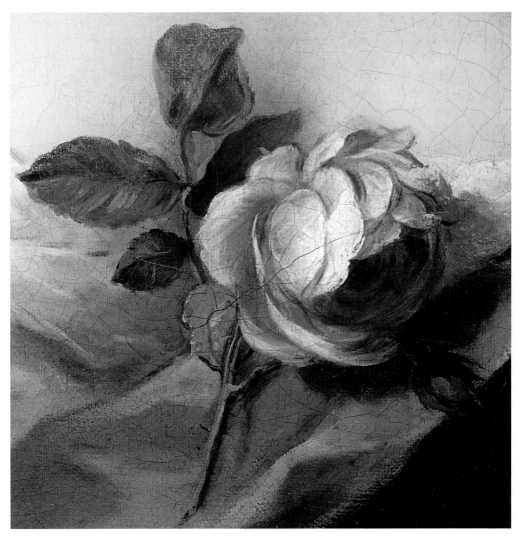

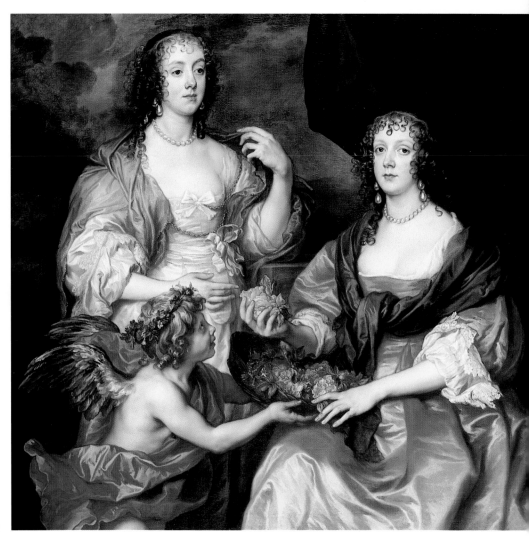

56

ANTHONY VAN DYCK (1599–1641) Dutch
Lady Elizabeth Thimbelby and Dorothy, Viscountess Andover
about 1637

Gather ye rose-buds while ye may,
Old Time is still a flying:
And this same flower that smiles today,
Tomorrow will be dying.

The glorious lamp of heaven, the sun,
The higher he's a getting;
The sooner will his race be run,
And nearer he's to setting.

That age is best, which is the first,
When youth and blood are warmer;
But being spent, the worse, and worst
Times, still succeed the former.

Then be not coy, but use your time;
And while ye may, go marry:
For having lost but once your prime,
You may forever tarry.

To the Virgins, to Make Much of Time,
ROBERT HERRICK, 1648

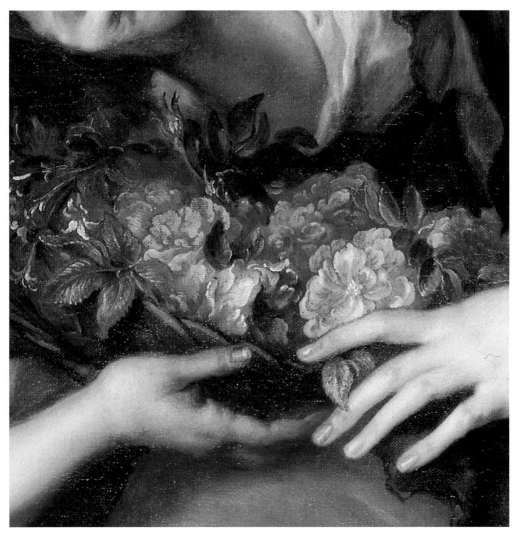

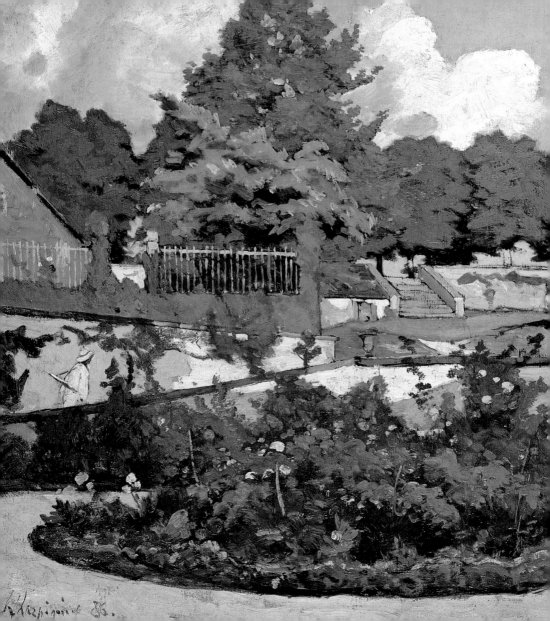

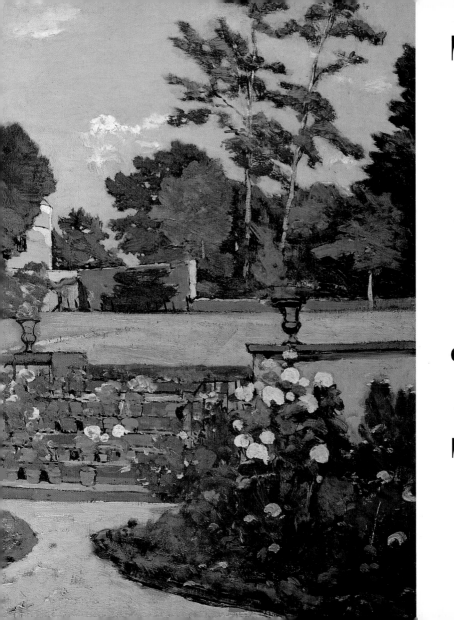

cultivated

61

PAULUS THEODORUS VAN BRUSSEL
(1754–1795) Dutch
Fruit and Flowers
1789

A bee allured by the perfume
Of a rich pineapple in bloom,
Found it within a frame enclosed,
And licked the glass that interposed.
Blossoms of apricot and peach,
The flowers that blowed within his reach,
Were arrant drugs compared with that
He strove so vainly to get at.
No rose could yield so rare a treat,
No jessamine was half so sweet.
The gardener saw this much ado,
(The gardener was the master too)
And thus he said—'Poor restless bee!
I learn philosophy from thee—
I learn how just it is and wise,
To use what Providence supplies,
To leave fine title, lordships, graces,
Rich pensions, dignities and places,

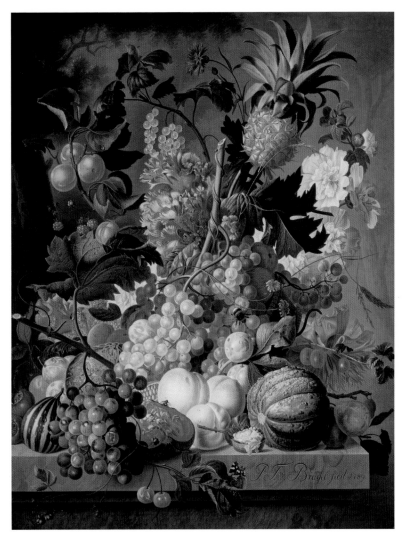

Those gifts of a superior kind,
To those for whom they were designed.
I learn that comfort dwells alone
In that which Heaven has made our own,
That fools incur no greater pain
Than pleasure coveted in vain.'

The Bee and the Pineapple,
WILLIAM COWPER, 1779

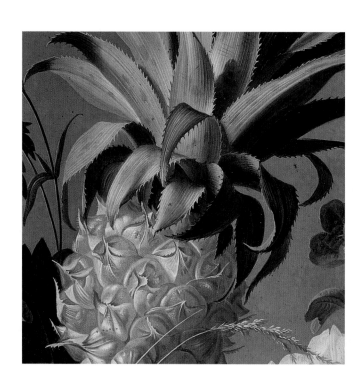

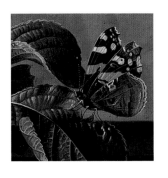

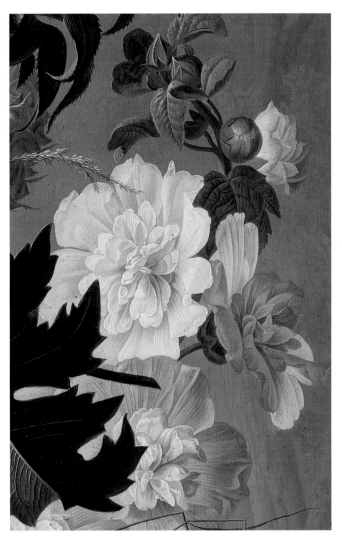

LAURENT DE LA HYRE (1606–1656) French
Allegorical Figure of Grammar
1650

1

Somewhere in Burma, with no special effort
And ignorant of its name, this lily grew,
Making sure of survival three times over
Like other delicate kinds: by simple seed
(Requiring fertilization), stem bulbil and bulb scale—
The last to insure that even the parent's decay
Should be potent for propagation; and still grows there
If the same graeco-latinizing species
That classified the lily and gave itself
The name of *homo sapiens* has left intact
This lily's habitat, somewhere in Burma.

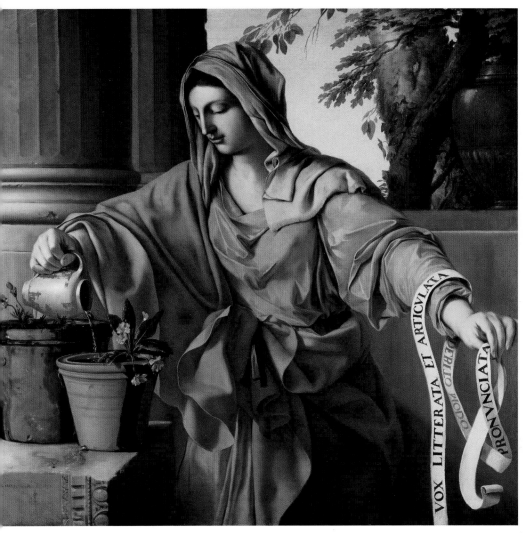

VOX LITTERATA ET ARTICVLATA DEBITO MODO PRONVNCIATA

2

Twenty-odd years ago a colleague gave me
A seed—or was it a bulbil?
Intrigued by the name, by the rarity,
And expecting a flower all sulphur-yellow,
I potted the thing, raised a seedling,
Saw it die down, reappear,
Watered, fed it, repotted it,
Moved it from house to house, from county to county,
Took bulbils again and again
From stems too slender to flower,
Potted new seedlings year after year,
Saw them die down, reappear,
Planted some out, kept others behind glass
Tried this and that, and waited and waited and waited;

from *Life and Art III*
MICHAEL HAMBURGER, 1979

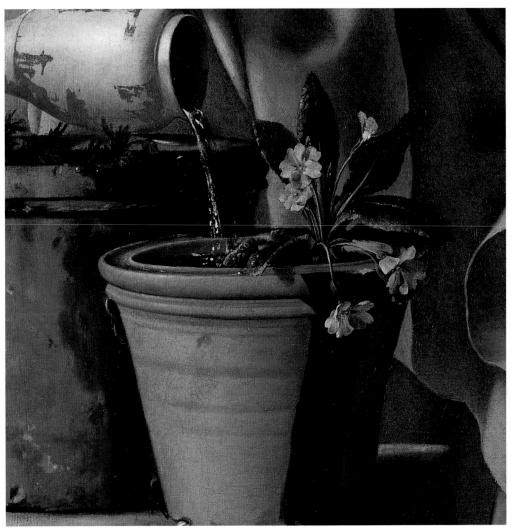

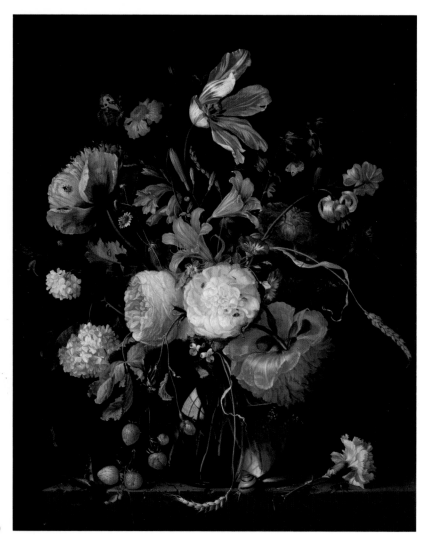

JACOB VAN WALSCAPPELLE (1644–1727) Dutch
Flowers in a Glass Vase
about 1670

Like foxgloves in the school of the grass moon
We come to terms with shade, with the principle
Of enfolding space. Our scissors in brocade,
We learn the coolness of straight edges, how
To gently stroke the necks of daffodils
And make them throw their heads back to the sun.

We slip the thready stems of violets, delay
The loveliness of the hibiscus dawn with quiet ovals,
Spirals of feverfew like water splashing,
The papery legacies of bluebells. We do
Sea-fans with sea-lavender, moon-arrangements
Roughly for the festival of moon-viewing.

This black container calls for sloes, sweet
Sultan, dainty nipplewort, in honour
Of a special guest, who summoned to the
Tea ceremony, must stoop to our low doorway,
Our fontanelle, the trout's dimpled feet.

The Flower Master,
MEDBH MCGUCKIAN, 1982

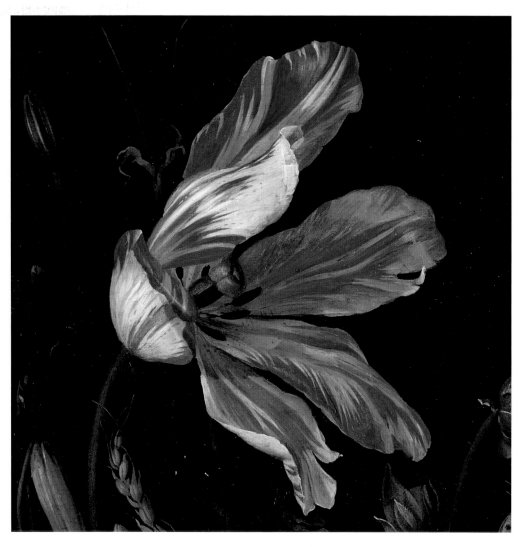

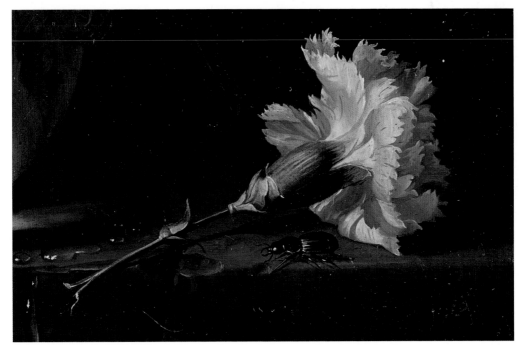

CLAUDE-OSCAR MONET (1840–1926)
French
The Water-Lily Pond
1899

…Maurice Kahn added: 'I sensed in these words a tinge of regret. For Monet, painting in the studio is not really painting…' They walked through the two gardens. The lily garden had a marked Japanese feel to it, which Monet said he had not consciously sought, but which M. Hayashi, a Japanese resident of Paris, had also remarked upon. When they reached the pond, Monet beamed with false modesty 'under his great parasol… leaning down towards his beloved lilies.' He could not resist a little joke: 'Gardening and painting apart, I'm no good at anything.' Which leads the reporter to conclude: 'Having seen Claude Monet in his garden, one understands why such a gardener paints as he does.'

from *Monet or the Triumph of Impressionism,*
DANIEL WILDENSTEIN, 1999

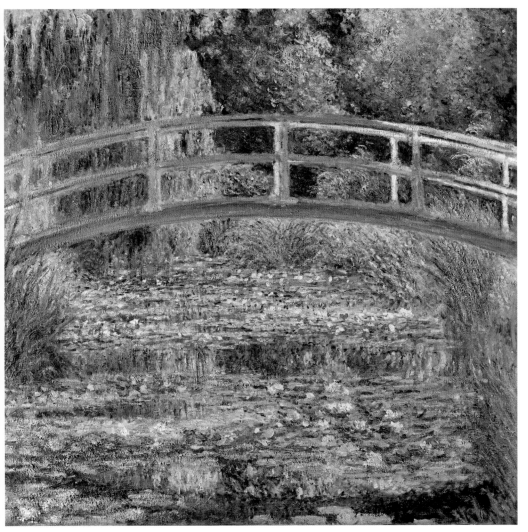

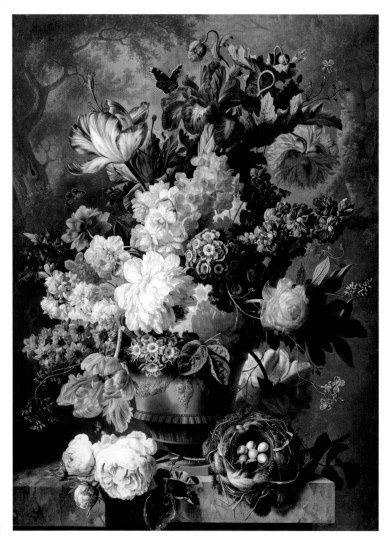

PAULUS THEODORUS VAN BRUSSEL
(1754–1795) Dutch
Flowers in a Vase
1792

Along these blushing borders, bright with dew,
And in yon mingled wilderness of flowers,
Fair-handed Spring unbosoms every grace;
Throws out the snowdrop, and the crocus first;
The daisy, primrose, violet darkly blue,
And polyanthus of unnumber'd dyes;
The yellow wall-flower, stain'd with iron brown;
And lavish stock that scents the garden round:
From the soft wing of vernal breezes shed,
Anemonies; auriculas, enrich'd
With shining meal o'er all their velvet leaves;
And full ranunculas, of glowing red.
Then comes the tulip-race, where Beauty plays
Her idle freaks; from family diffus'd
To family, as flies the father dust,

The varied colours run; and, while they break
On the charm'd eye, th'exulting florist marks,
With secret pride, the wonders of his hand.
No gradual bloom is wanting; from the bud,
First-born of Spring, to Summer's musky tribes;
Nor hyacinths, of purest virgin white,
Low-bent, and blushing inward; nor jonquilles,
Of potent fragrance; nor narcissus fair,
As o'er the fabled fountain hanging still;
Nor broad carnations, nor gay-spotted pinks;
Now, shower'd from every bush, the damask rose.
Infinite numbers, delicacies, smells,
With hues on hues expression cannot paint,
The breath of Nature, and her endless bloom.

from *The Seasons,*
JAMES THOMSON, 1746

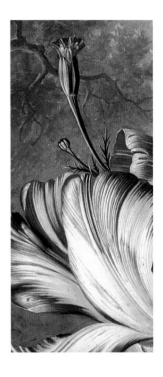

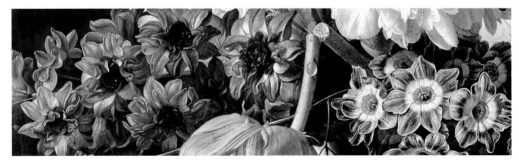

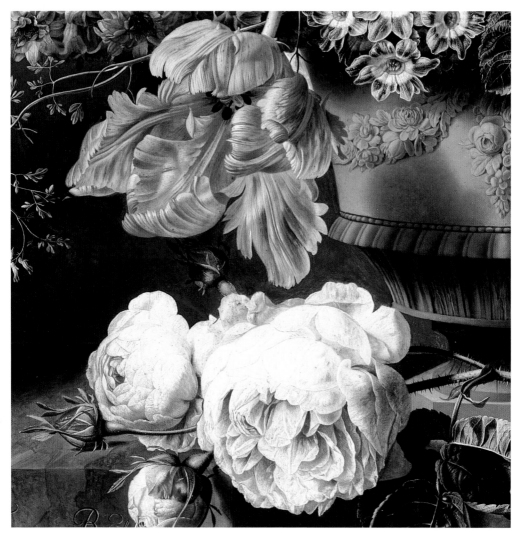

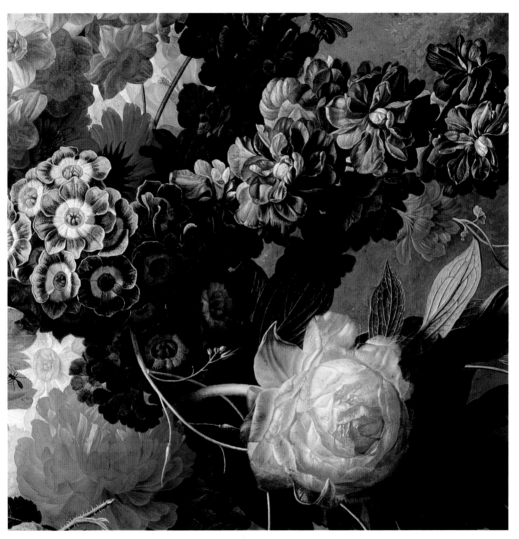

IGNACE-HENRI-THÉODORE FANTIN-LATOUR
(1836–1904) French
Still Life with Glass Jug, Fruit and Flowers
1861

There were the roses, in the rain.
Don't cut them, I pleaded.
They won't last, she said.
But they're so beautiful where they are.
Agh, we were all beautiful once, she said,
and cut them and gave them to me in my hand.

The Act,
WILLIAM CARLOS WILLIAMS, 1948

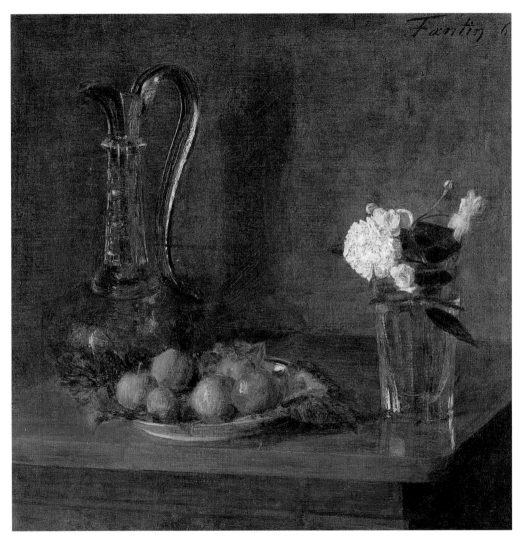

wild

ATTRIBUTED TO JAN PROVOOST
(living 1491; died 1529) French
The Virgin and Child in a Landscape
early 16th century

I must die! O was I born
For time's malice and man's scorn?

Look, where at your feet the Plant,
Love's pilgrim and poor suppliant,
With a leaf like a small hand
Signals to you from the sand;
With a flower like a blue eye
Propounds love's dreadful mystery;
With a weak triumphant spire
Soars to a peak of pure desire.
So poor, so circumscribed she stands,
Foot-fast; and yet her little hands
Sweep in spirals, and describe
The old pattern of her tribe,
Her awful rune, the which she must
Repeat ere she return to dust,
Completing with a meagre seed
The implacable and humble need,
The spell, the prayer, the proud pavane,
Conceived before those hills began.

The Small Plant,
RUTH PITTER, 1945

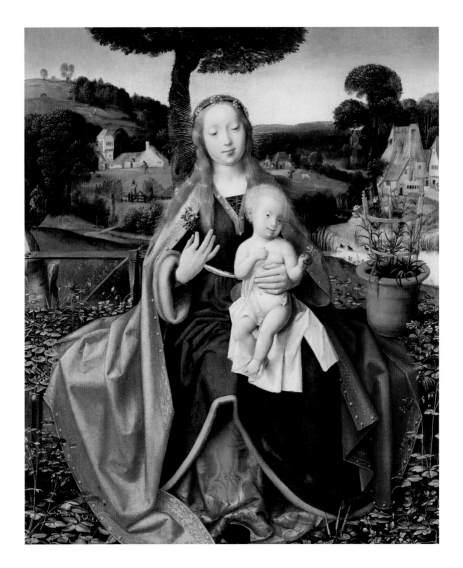

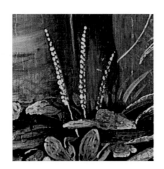
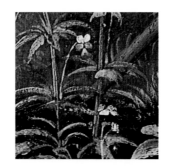
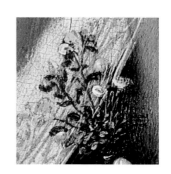
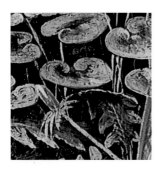

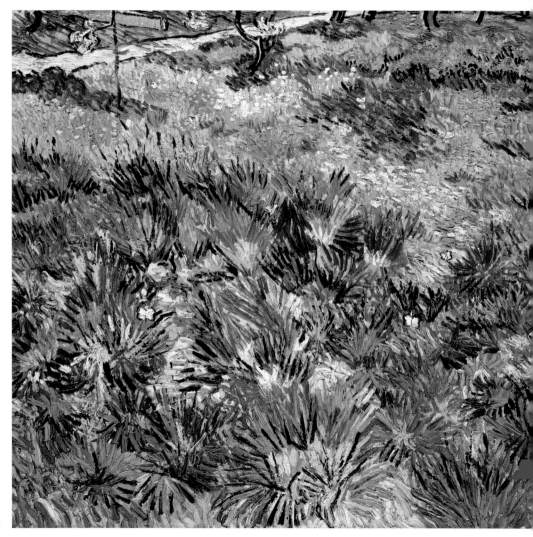

Vincent van Gogh (1853–1890) Dutch
Long Grass with Butterflies
1890

Pile the bodies high at Austerlitz and Waterloo.
Shovel them under and let me work—
I am the grass; I cover all.

And pile them high at Gettysburg
And pile them high at Ypres and Verdun.
Shovel them under and let me work.
Two years, ten years, and passengers ask the conductor:
What place is this?
Where are we now?

I am the grass.
Let me work.

Grass,
Carl Sandburg, 1918

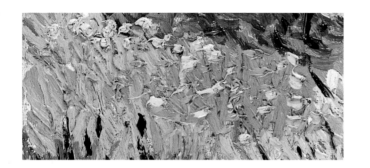

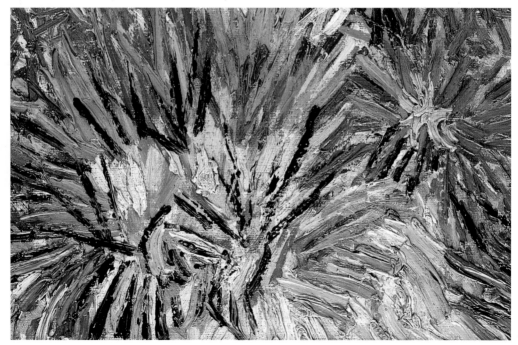

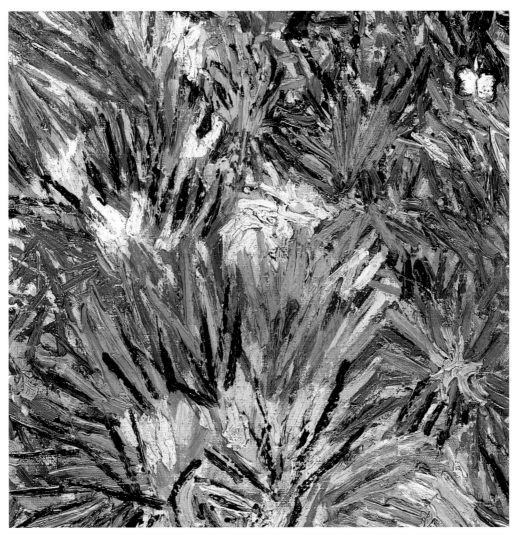

JAN GOSSAERT
(active 1503; died 1532) Flemish
The Adoration of the Kings
1500–15

Flower in the crannied wall
I pluck you out of the crannies,
I hold you here, root and all, in my hand,
Little flower—but if I could understand
What you are, root and all, and all in all,
I should know what God and man is.

from *Flower in the Crannied Wall,*
ALFRED, LORD TENNYSON, 19th century

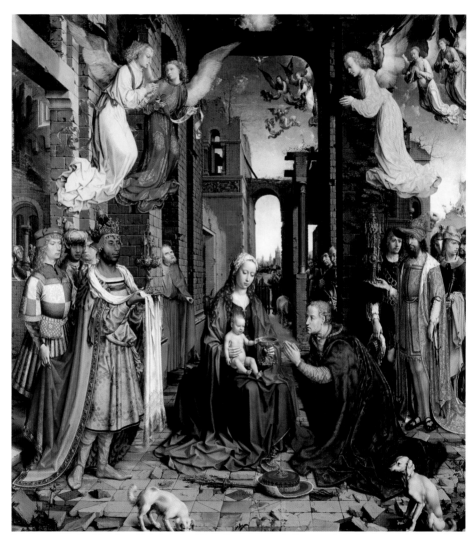

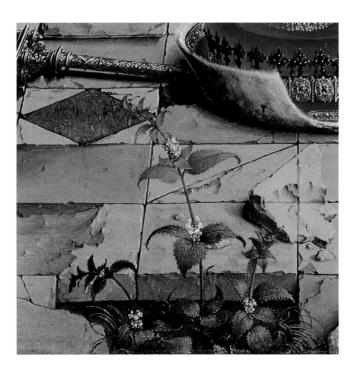

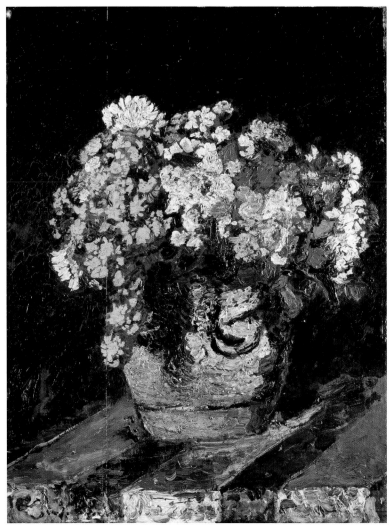

ADOLPHE MONTICELLI
(1824–1886) French
A Vase of Wild Flowers
probably 1870–80

The garden mould was damp and chill,
Winter had had his brutal will
Since over all the year's content
His devastating legions went.
Then Spring's bright banners came: there woke
Millions of little growing folk
Who thrilled to know the winter done,
Gave thanks, and strove towards the sun.
Not so the elect; reserved, and slow
To trust a stranger-sun and grow,
They hesitated, cowered and hid
Waiting to see what others did.
Yet even they, a little, grew,
Put out prim leaves to day and dew,
And lifted level formal heads
In their appointed garden beds.

The gardener came: he coldly loved
The flowers that lived as he approved,
That duly, decorously grew
As he, the despot, meant them to.
He saw the wildlings flower more brave
And bright than any cultured slave;
Yet, since he had not set them there,
He hated them for being fair.
So he uprooted, one by one
The free things that had loved the sun,
The happy, eager, fruitful seeds
That had not known that they were weeds.

The Despot,
EDITH NESBIT, 1922

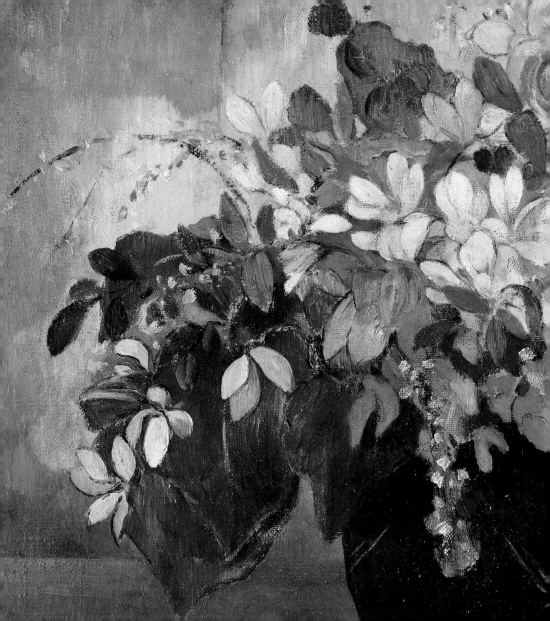

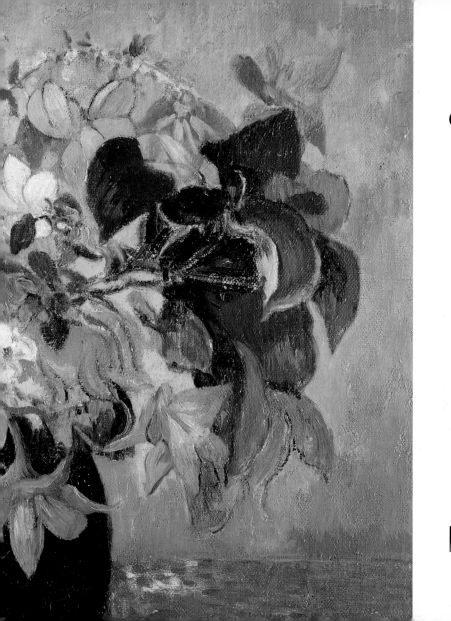

domestic

JAN VAN HUYSUM (1682–1749) Dutch
Hollyhocks and Other Flowers in a Vase
1702–20

…By far the most gorgeous flower-jar that I ever made was
of double white narcissus studded with choice ranunculuses,
not hanging loose but packed tightly together. White
hollyhocks too mixed with others of rich colour either in a
tall jar with all their long spikes, for the bud of the
hollyhock is beautiful and so is the peculiar green looking
like a daisied lawn on a dewy morning—either in that form
or the single blossoms laid closely together in a china dish
are very bright and gay. So are dahlias, and dahlias look
especially well arranged in a china bowl with a wire frame of
the same sphere-like form, into which to insert the stalks.
It makes a splendid globe of colour.

<div align="right">

from a letter to John Ruskin,
MARY RUSSELL MITFORD, 1854

</div>

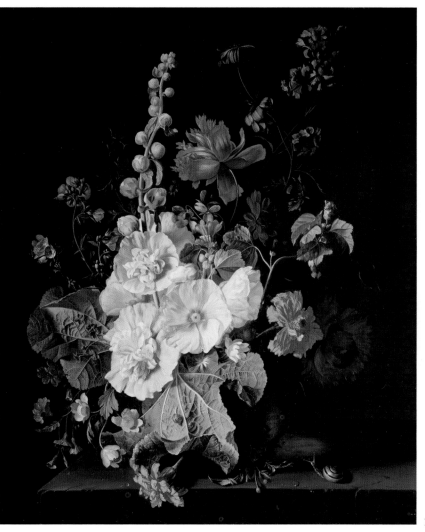

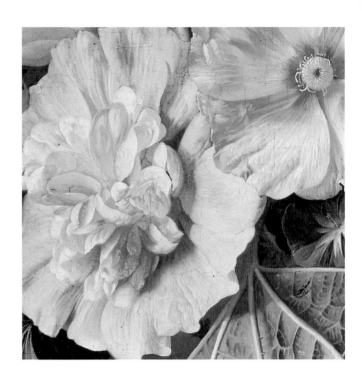

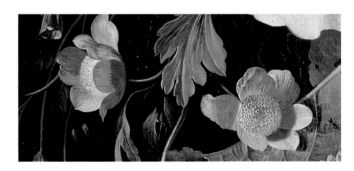

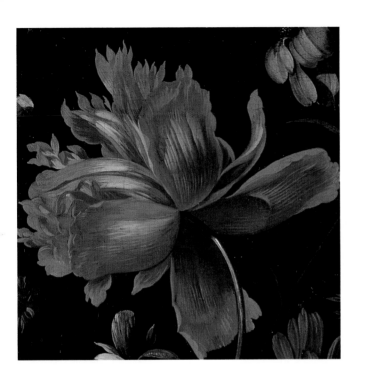

VINCENT VAN GOGH
(1853–1890) Dutch
Sunflowers
1888

Ah Sunflower, weary of time,
Who countest the steps of the sun;
Seeking after that sweet golden clime
Where the traveller's journey is done;

Where the Youth pined away with desire,
And the pale virgin shrouded in snow,
Arise from their graves, and aspire
Where my Sunflower wishes to go!

<div align="right">

Ah Sunflower,
WILLIAM BLAKE, 1794

</div>

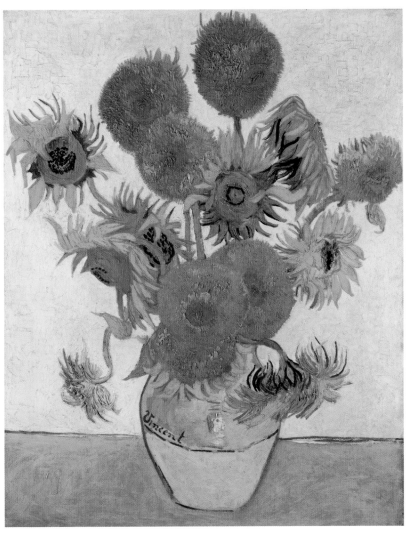

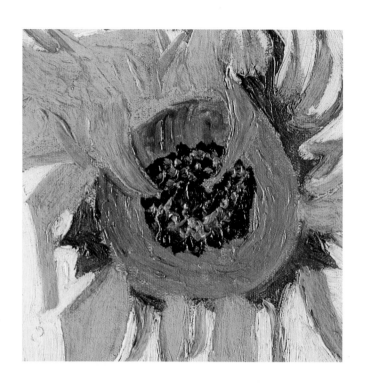

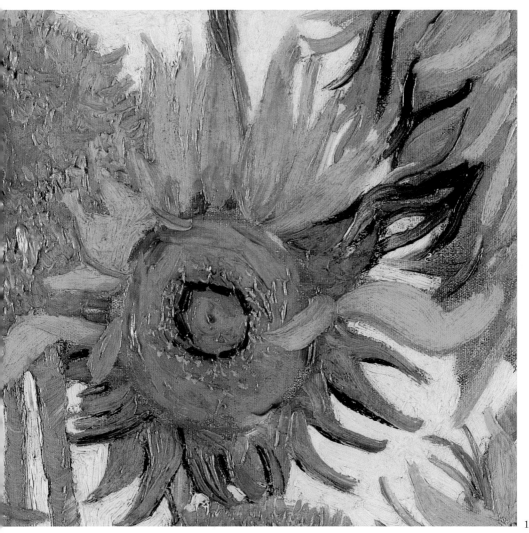

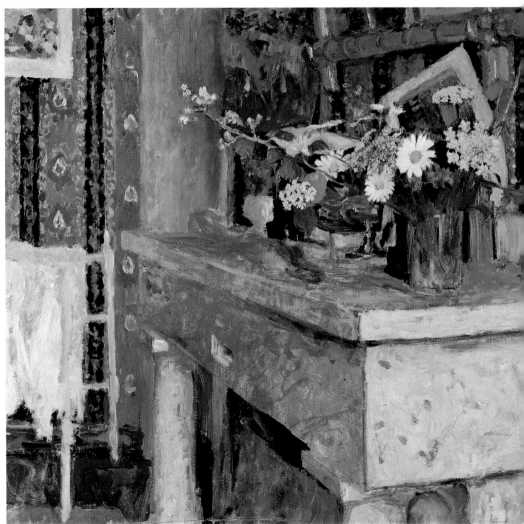

EDOUARD VUILLARD
(1868–1940) French
The Mantelpiece (La Cheminée)
1905

With little here to do or see
Of things that in the great world be,
Daisy! again I talk to thee,
For thou art worthy,
Thou unassuming Common-place
Of Nature, with that homely face,
And yet with something of a grace,
Which Love makes for thee!

Oft on the dappled turf at ease
I sit, and play with similies,
Loose types of things through all degrees,
Thoughts of thy raising:
And many a fond and idle name
I give to thee, for praise or blame,
As in the humour of the game,
While I am gazing.

A nun demure of lowly port;
Or sprightly maiden, of Love's court,
In thy simplicity the sport
Of all temptations;
A queen in crown of rubies drest;
A starveling in a scanty vest;
Are all, as seems to suit thee best,
Thy appellations.

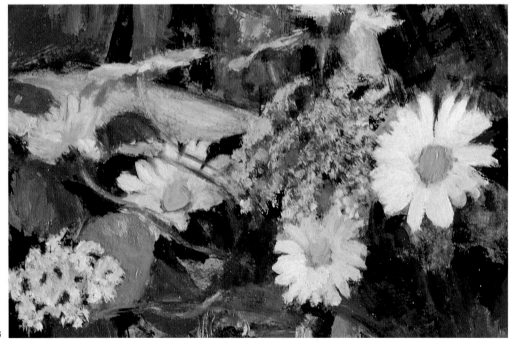

A little cyclops, with one eye
Staring to threaten and defy,
That thought comes next—and instantly
The freak is over,
The shape will vanish—and behold
A silver shield with boss of gold,
That spreads itself, some faery bold
In fight to cover!

I see the glittering from afar—
And then thou art a pretty star;
Not quite so fair as many are
In heaven above thee!
Yet like a star, with glittering crest,
Self-poised in air thou seem'st to rest;—
May peace come never to his nest,
Who shall reprove thee!

Bright Flower! for by that name at last,
When all my reveries are past,
I call thee, and to that cleave fast,
Sweet silent creature!
That breath'st with me in sun and air,
Do thou, as thou art won, repair
My heart with gladness, and a share
Of thy meek nature!

from *To the Daisy,*
WILLIAM WORDSWORTH, 1802

OTTO FRANZ SCHOLDERER (1834–1902) German
Lilac
about 1860–1902

The lilac-scent, the bushes, and the dark green, heart-shaped leaves,
Wood violets, the little delicate pale blossoms called innocence,
Samples and sorts not for themselves alone, but for their atmosphere,
To tally, drench'd with them, tested by them,
Cities and artificial life, and all their sights and scenes,
My mind henceforth, and all its meditations—my recitatives,
My land, my age, my race, for once to serve in songs,
(Sprouts, tokens ever of death indeed the same as life,)
To grace the bush I love—to sing with the birds,
A warble for joy of Lilac-time, returning in reminiscence.

from *Song of Myself,*
WALT WHITMAN, 1855

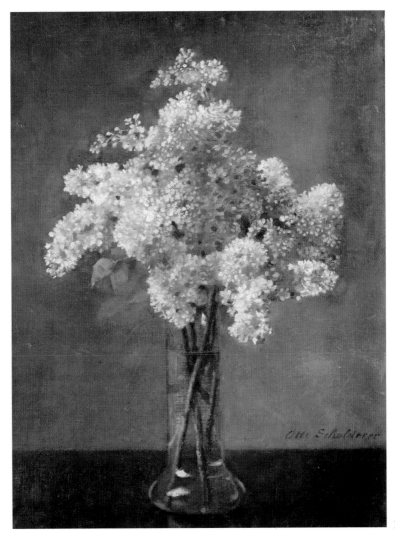

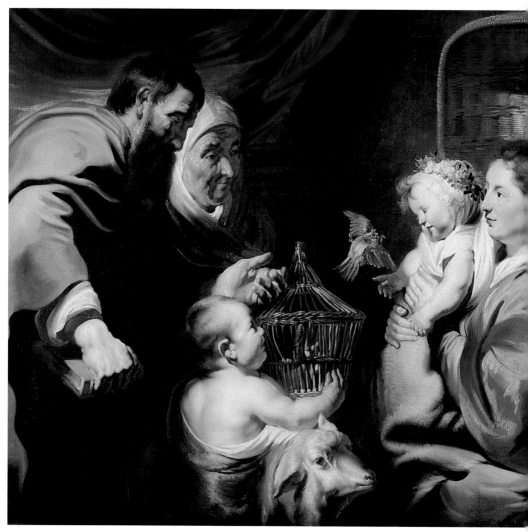

JACOB JORDAENS (1593–1678) Dutch
The Virgin and Child with Saints Zacharias,
Elizabeth and John the Baptist
about 1620

Twist me a crown of wind-flowers;
That I may fly away
To hear the singers at their song,
And players at their play.

Put on your crown of wind-flowers:
But whither would you go?
Beyond the surging of the sea
And the storms that blow.

Alas! your crown of wind-flowers
Can never make you fly:
I twist them in a crown today
And tonight they die.

Twist me a Crown of Wind-flowers,
CHRISTINA ROSSETTI, 1869

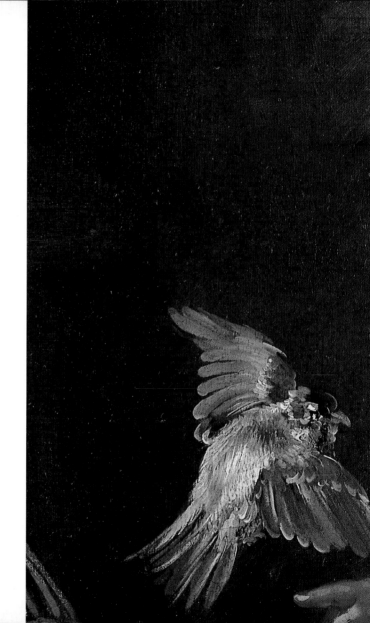

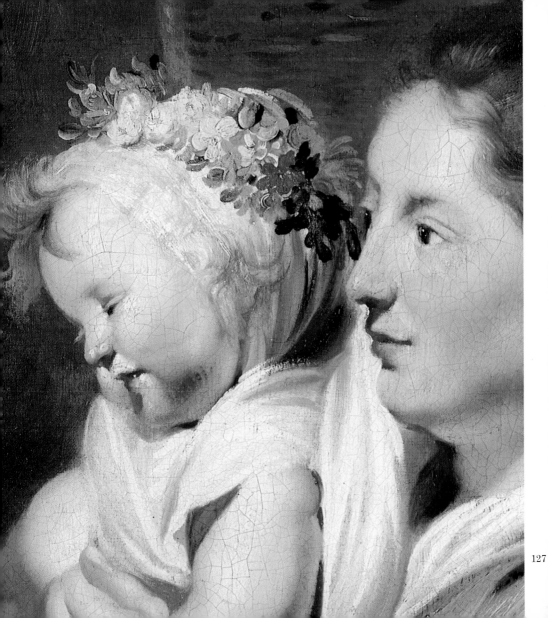

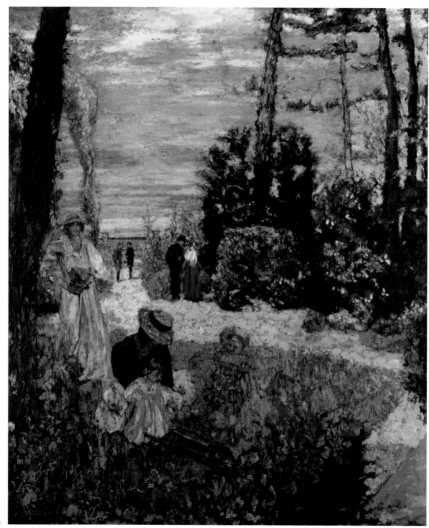

EDOUARD VUILLARD
(1868–1940) French
Lunch at Vasouy
1901, reworked 1935

This is mint and here are three pinks
I have brought you, Mother.
They are wet with rain
And shining with it.
The pinks smell like more of them
In a blue vase:
The mint smells like summer
In many gardens.

Gift,
HILDA CONKLING, 1920

CLAUDE-OSCAR MONET
(1840–1926) French
Irises
about 1914–17

I have a small grain of hope—
one small crystal that gleams
clear colors out of transparency.

I need more.

I break off a fragment
to send you.

Please take
this grain of a grain of hope
so that mine won't shrink.

Please share your fragment
so that yours will grow.

Only so, by division,
will hope increase,

like a clump of irises, which will cease to flower
unless you distribute
the clustered roots, unlikely source—
clumsy and earth-covered—
of grace.

For the New Year, 1981,
DENISE LEVERTOV, 1982

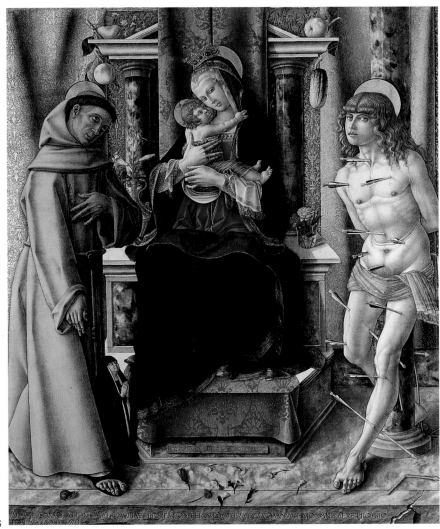

CARLO CRIVELLI
(about 1430/35 to about 1494) Italian
The Virgin and Child with Saints Francis and Sebastian
1491

Containers can be found around the house and used for
small arrangements. They don't have to be vases. They
could be, perhaps, a pretty cup and saucer, a coffee cup,
a small milk jug or even an old silver teapot or sauce-
boat filled with spring flowers.

Glass is pretty especially when filled with gypsophilia
(Baby's Breath), sweet peas or white petunias. Custard
glasses and brandy snifters are useful for this. And
silver—a silver salt cellar could be a size between small
and miniature, and silver sugar bowls or *sucriers* filled
with a mixed summer bunch are ideal. Mugs and small
jugs are, of course, useful and candlesticks with metal
candle cups placed in the top are lovely for a summer
evening party, or for Christmas with cascading red
ribbons tied to a posy at the place of each guest. There
are very many objects around the house that one has
never thought to use ...

from *The New Flower Arranging from your Garden,*
SHEILA MACQUEEN, 1977

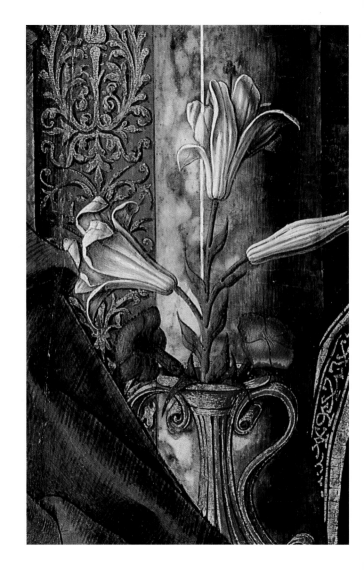

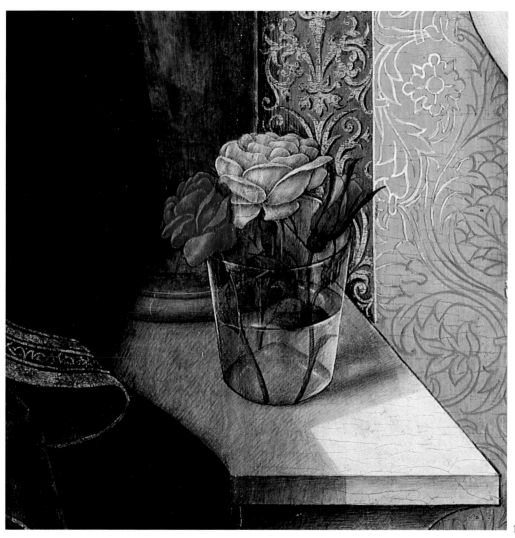

Artists & Paintings

BELLINI, Giovanni, workshop
of *Saint Dominic*
oil on canvas,
63.9 x 49.5 cm, p.27

BOUCHER, François, studio of
The Billet-Doux
oil on canvas,
95.3 x 127 cm, p.48

BRUSSEL, Paulus Theodorus
van
Flowers in a Vase
oil on mahogany,
81.1 x 58.9 cm, p.78

Fruit and Flowers
oil on mahogany,
78.4 x 61 cm, p.63

CARAVAGGIO, Michelangelo
Merisi da
Boy bitten by a Lizard
oil (identified) on canvas,
66 x 49.5 cm, p.22

COURBET, Jean-Désiré-
Gustave
*Young Ladies on the Bank of the
Seine*
oil on canvas,
96.5 x 130 cm, p.88

CRIVELLI, Carlo
*The Virgin and Child with
Saints Francis and Sebastian*
egg and oil (identified) on
poplar,
175.3 x 151.1 cm, p.136

DOLCI, Carlo
*The Virgin and Child with
Flowers*
oil on canvas,
78.1 x 63.2 cm, p.34

DYCK, Anthony van
*Lady Elizabeth Thimbelby and
Dorothy, Viscountess Andover*
oil (identified) on canvas,
132.1 x 149 cm, p.56

FANTIN-LATOUR, Ignace-
Henri-Théodore
A Basket of Roses
oil on canvas, 48.9 x 60.3 cm,
p.38

*Still Life with Glass Jug, Fruit
and Flowers*
oil on canvas,
47 x 47.6 cm, p.85

The Rosy Wealth of June
oil on canvas,
70.5 x 61.6 cm, p.6

GAUGUIN, Paul
A Vase of Flowers
oil on canvas,
64 x 74 cm, p.106
German, South

Portrait of a Man
oil on beech,
49.9 x 39.1 cm, p.31

GOGH, Vincent van
Long Grass with Butterflies
oil on canvas,
64.5 x 80.7 cm, p.94

Sunflowers
oil (identified) on canvas,
92.1 x 73 cm, p.113

GOSSAERT, Jan
The Adoration of the Kings
oil (identified) on wood,
177.2 x 161.3 cm, p.99

HARPIGNIES, Henri-Joseph
*The Painter's Garden at Saint-
Privé*
oil on canvas, 59.7 x 81.3 cm,
p.60

WRITERS & WORKS

BLAKE, William
(1757–1827), English
Ah Sunflower, 1794, p.112

BROOKE, Rupert
(1887–1915), English
from *Mary and Gabriel,*
1912, p.16

CAMPION, Thomas
(1567–1620), English
*There Is a Garden in her
Face,* 1617, p.41

CONKLING, Hilda
(b. 1910), English
Gift, 1920, p.129

COWPER, William
(1731–1800), English
The Bee and the Pineapple,
1779, p.62

HAMBURGER, Michael
(b. 1924), British
from *Life and Art III,* 1979,
p.66

HERBERT, George
(1593–1633), English
from *The Flower,* 1633, p.30

HERRICK, Robert
(1591–1674), English

*To the Virgins, to make Much
of Time,* 1648, p.57

LANIER, Sidney
(1842–1881), American
*To My Class: On Certain
Fruits and Flowers Sent Me
in Sickness,* 1884, p.23

LEVERTOV, Denise
(1923–1997), American
For the New Year, 1981,
1982, p.132

LOVELACE, Richard
(1618–1657), English
To Lucasta: The Rose, 17th
century, p.19

McGUCKIAN, Medbh
(b. 1950), Irish
The Flower Master, 1982,
p.71

MacQUEEN, Sheila
from *The New Flower
Arranging from your Garden,*
1977, p.137

MITFORD, Mary Russell
(1786–1855), English
from a letter to John Ruskin,
1854, p.108

MUSSET, Alfred de
(1810–1857), French
Forget Me Not, 19th century,
p.11

NESBIT, Edith
(1858–1924), English
The Despot, 1922, p.103

O'REILLY, John Boyle
(1844–1890), Irish
A White Rose, 19th century,
p.48

PITTER, Ruth
(1897–1992), English
Lilies and Wine, 1945, p.26

The Small Plant, 1945, p.90

RAINE, Kathleen
(b. 1908), English
A Dream of Roses, 1971, p.44

ROSSETTI, Christina
(1830–1894), English
A Rose Plant in Jericho,
1873, p.35

*Twist me a Crown of Wind-
flowers,* 1869, p.125

Acknowledgments

Sandburg, Carl
(1878–1967), American
Grass, 1918, p.95

Tennyson, Lord Alfred
(1809–1892), English
Flower in the Crannied Wall,
19th century, p.98

Thomson, James
(1700–1748), Scottish
from *The Seasons,* 1746, p.79

Turner, Steve
(b. 1949), English
*My Love is like a Red, Red
Rose,* 1996, p.52

Whitman, Walt
(1819–1892), American
from *Song of Myself,* 1855,
p.120

Wildenstein, Daniel
(b. 1917), French
from *Monet,* 1999, p.74

Williams, William Carlos
(1883–1963), American
The Act, 1948, p.84

Wordsworth, William
(1770–1850), English
from *To the Daisy,* 1802,
p.117

The editor and publishers
gratefully acknowledge
permission to reprint copyright
material listed below. Every
effort has been made to contact
the original copyright holders
of the material included. Any
omissions will be rectified in
future editions.

For the New Year, 1981 by
Denise Levertov, from *Candles
in Babylon,* copyright © 1982
by Denise Levertov. Reprinted
by permission of New
Directions Publishing Corp.

The Flower Master by Medbh
McGuckian from *The Flower
Master and Other Poems,*
published by kind permission
of the author and The Gallery
Press.

Excerpt from *Life and Art III*
by Michael Hamburger from
*Michael Hamburger: Collected
Poems 1941–1994* published by
Anvil Press Poetry, 1995.

Lilies and Wine and *The Small
Plant* by Ruth Pitter reprinted
by permission of Mark Pitter.

A Dream of Roses by Kathleen
Raine from *The Lost Country,*
reprinted by permission of
Golgonooza Press.

Grass from *Cornhuskers* by
Carl Sandburg, copyright 1918
by Holt, Rinehart and Winston
and renewed 1946 by Carl
Sandburg, reprinted by
permission of Harcourt, Inc.

*My Love is Like a Red, Red
Rose* by Steve Turner taken
from *The Day I Fell Down the
Toilet* by Steve Turner,
published by Lion Publishing
plc and reproduced by
permission.

The Act by William Carlos
Williams, from *Collected Poems
1939–1962, Volume II,*
copyright © by William Carlos
Williams. Reprinted by
permission of New Directions
Publishing Corp and Carcanet
Press Ltd.

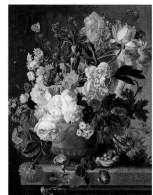

Title page: Paulus Theodorus van Brussel, *Flowers in a Vase*, 1789

Symbolic title page: attributed to Lo Spagna, *The Agony in the Garden*, perhaps 1500–5

Romantic title page: Ignace-Henri-Théodore Fantin-Latour, *A Basket of Roses*, 1890

Cultivated title page: Henri-Joseph Harpignies, *The Painter's Garden at Saint-Privé*, 1886

Wild title page: Jean-Désiré-Gustave Courbet, *Young Ladies on the Bank of the Seine*, before 1857

Domestic title page: Paul Gauguin, *A Vase of Flowers*, 1896